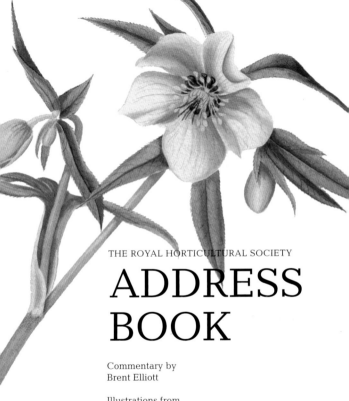

THE ROYAL HORTICULTURAL SOCIETY

ADDRESS BOOK

Commentary by
Brent Elliott

Illustrations from
the Royal Horticultural Society's
Lindley Library

F

FRANCES LINCOLN LIMITED
PUBLISHERS

Frances Lincoln Limited
4 Torriano Mews
Torriano Avenue
London NW5 2RZ
www.franceslincoln.com

*The Royal Horticultural Society Pocket
Address Book*
Copyright © Frances Lincoln limited 2010

First Frances Lincoln edition 2010

A catalogue record for this book is available
from the British Library

ISBN: 978-0-7112-3097-2

Printed in China

9 8 7 6 5 4 3 2 1

Front cover *Trillium catesbyi* (formerly known
under the obsolete spelling *catesbaei*), native
to the southeast United States and named for
the 18th-century naturalist Mark Catesby, was
introduced in the 1820s but little grown in British
gardens until after the Second World War. First
published in *The complete flower paintings*
(1987).

Back cover *Camellia × williamsii* 'Citation', a
cultivar which originated at Bodnant (NT) before
1960. First published in *Gardens of the National
Trust (1979)*.

Title page *Helleborus* 'Bowles's Yellow'. Bowles
gave his plant to the Cambridge Botanic Garden,
and Graham Thomas was given a clump during
his apprenticeship there in the late 1920s. As
it did not come true from seed, he could not
determine its ancestry, and called it 'Bowles's
Yellow'; unfortunately, it was last listed in the
RHS Plant Finder in 2000. First published in
Colour in the winter garden (1967).

**The following books by Graham Stuart Thomas
are available from Frances Lincoln:**
Ornamental Shrubs
Climbers and Bamboos
Perennial Garden Plants
Recollections of Great Gardeners
The Graham Stuart Thomas Rose Book
The Rock Garden and its Plants
Trees in the Landscape
www.franceslincoln.com

GRAHAM STUART THOMAS 1909–2003

2009 saw the centenary of the birth of Graham Stuart Thomas, who was probably the most influential British gardener of the twentieth century (though he would always have denied it; that accolade, he would have said, belonged to Gertrude Jekyll, whom he met in his youth). He was a distinguished nurseryman for thirty years, first with T. Hilling and Co., and then with Sunningdale; the youngest member appointed to the RHS Floral Committee; a garden designer; the author of 17 books and major pamphlets on subjects ranging from rock gardens to ground cover to winter gardening; and mid-century Britain's most eminent authority on roses. And beyond all this, he was for twenty years (1955–1974) the Gardens Advisor to the National Trust, and the man who effectively made the restoration of historic gardens part of British cultural life.

But he was also an artist. His father was an artist, and his juvenile notebooks show him quickly developing a knack for perspective drawing and an interest in plants. As first a calligrapher and then as an artist, he helped to design the catalogues published by Hilling and Sunningdale. But it was not until 1962, and the publication of *Shrub roses of today*, that he used his drawings to illustrate one of his proper books.

Thereafter, his paintings and drawings appeared in, among others, his books on roses, his autobiography *Three gardens*, and his magnificent book on *Gardens of the National Trust* (1979), which included pencil sketches of garden scenes as well as portraits of plants.

In 1987, he published *The complete flower paintings and drawings of Graham Stuart Thomas*, bringing together in one volume the works both in pencil and in watercolours that he had hitherto published, as well as many drawings that had never appeared before. All but a few of the drawings reproduced in this volume were included in that work. His 2002 volume *The garden throughout the year* reproduced some additional drawings, most likely new additions to his repertoire. Even so, the drawing *Lathyrus latifolius* has never been published before. None of the drawings are dated, a frustration for scholars, though in his publications he did record the dates of a few.

Many of the plants he drew had particular associations with National Trust gardens. Sometimes Graham Thomas introduced the plant into the Trust's gardens; sometimes he took it from a Trust garden and circulated it to the nursery trade.

Graham Thomas's legacy to British gardening was immense and varied, and his drawings are but a minor part of his work. Nonetheless he was a good and careful artist, and his work deserves to be remembered. The drawings reproduced in this volume are interesting not only as portraits of plants, but as records of the associations of the plants with particular British gardens and with the development of 20th-century horticulture.

Brent Elliott
THE ROYAL HORTICULTURAL SOCIETY

USEFUL ADDRESSES AND TELEPHONE NUMBERS

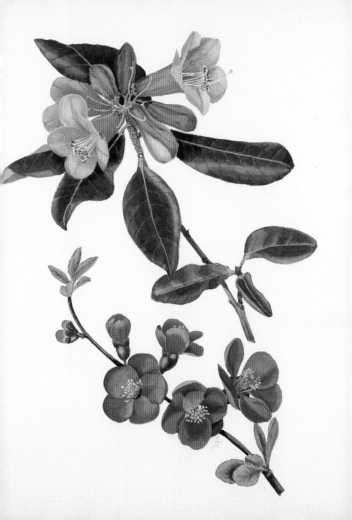

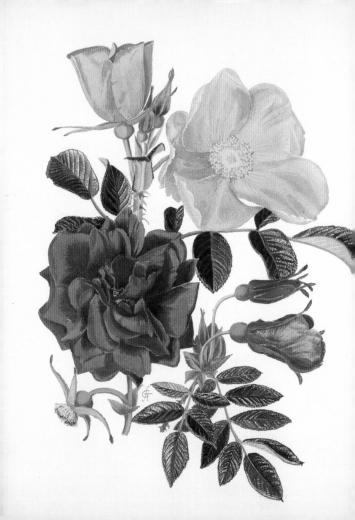

A

Rosa 'Fru Dagmar Hastrup', a Danish rose introduced just before the First World War, and *Rosa* 'Roseraie de l'Hay', a Hybrid Rugosa bred by the amateur rosarian Jules Gravereaux in 1901. First published in *Shrub roses of today* (1962).

A

Trillium catesbyi (formerly known under the obsolete spelling *catesbaei*), native to the southeast United States and named for the 18th-century naturalist Mark Catesby, was introduced in the 1820s but little grown in British gardens until after the Second World War. First published in *The complete flower paintings* (1987).

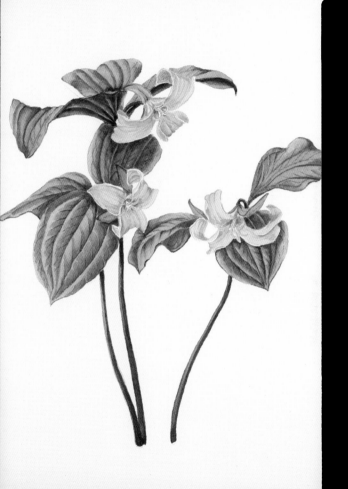

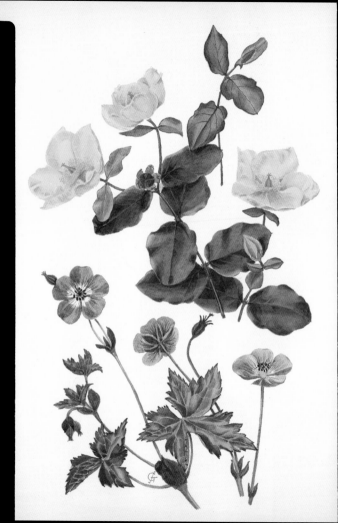

B

Two plants of Himalayan origin: *Hypericum bellum*, in the undulate-leaved form introduced by Ludlow and Sherriff in 1947, and below, *Geranium wallichianum* 'Buxton's Variety', which Thomas described as "a pearl beyond price". First published in Graham Stuart Thomas' *Three gardens* (1983).

B

B

B

Most of the roses depicted in this drawing (the obvious exception being 'Goldfinch', bred by George Paul in 1907) are Multiflora Ramblers. Shown here are 'Violette', a French "blue" cultivar (1921); 'Veilchenblau', a German "purple" cultivar (1909), and bred from it, 'Rosemarie Viaud' (1924); and 'Bleu Magenta', of unknown origin, distributed from the Roseraie de l'Hay in the 1950s as an unnamed cultivar. First published in *Climbing roses old and new* (1965).

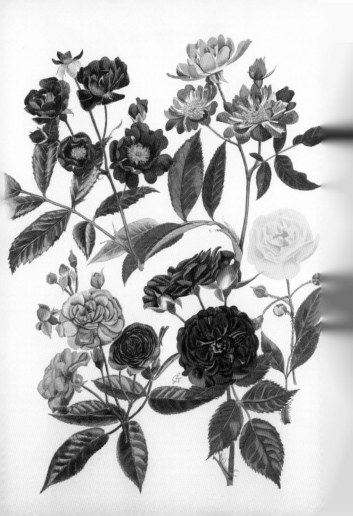

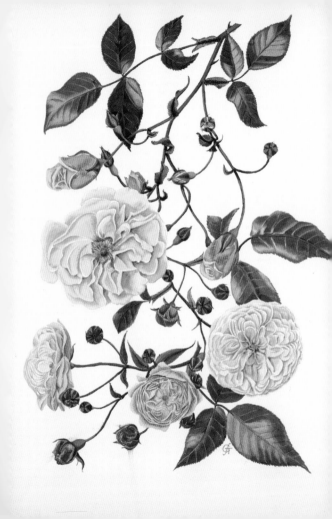

Three 19th-century roses: 'Adélaïde d'Orléans' and 'Félicité et Perpétue' (both raised by Louis Philippe's head gardener Jacques in the 1820s), and 'Spectabilis' (origin unknown, pre-1846). First published in *Climbing roses old and new* (1965).

C

C

C

Hosta minor, a Korean species, introduced in the 1870s. The name has been used confusingly, but this drawing shows the correct species. First published in *The complete flower paintings* (1987).

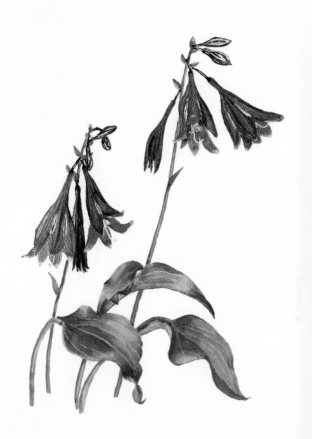

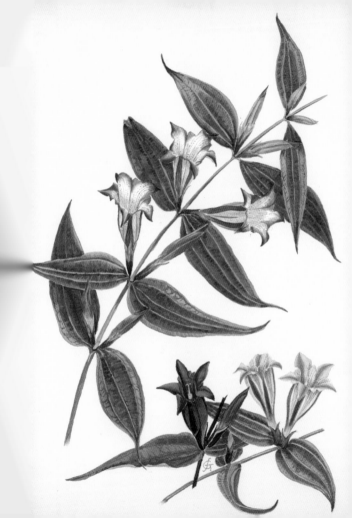

D

Gentiana asclepiadea 'Knightshayes', a cultivar raised at Knightshayes garden (NT) in the 1960s, together with a pale blue form, which Graham Thomas found at Wallington (NT), shown for comparison. First published in *Gardens of the National Trust* (1979).

D

D

D

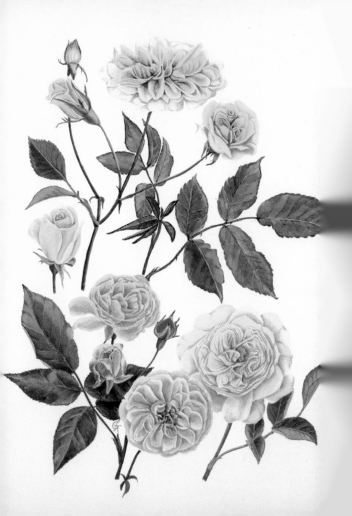

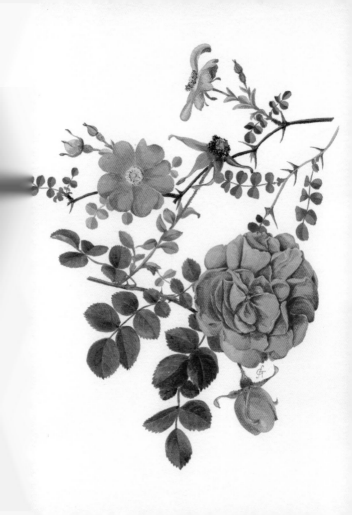

E

Rosa multibracteata, a Chinese species introduced by E.H. Wilson in 1910, with *Rosa* 'Cerise Bouquet', a cultivar launched by Wilhelm Kordes in 1958. First published in *Shrub roses of today* (1962).

E

E

E

A native insectivorous plant, *Pinguicula grandiflora*, which became popular after the publication of Darwin's book on *Insectivorous plants* (1875). Drawn in 1986, and published in *The complete flower paintings* (1987).

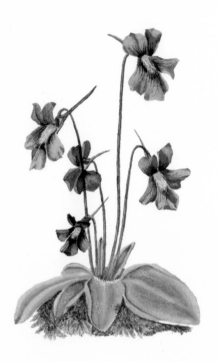

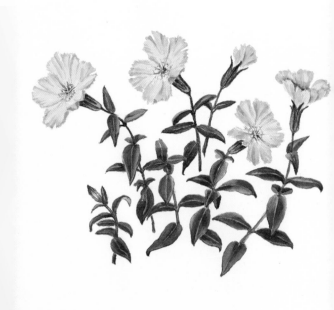

F

Silene keiskeii var. *akaisialpina*, a naturally occurring Japanese variety, last listed in the RHS *Plant Finder* in 2008. Drawn in 1986, and published in *The complete flower paintings* (1987).

F

F

F

Two species roses, *Rosa glauca* and *Rosa tedtschenkoana*, and the cultivar 'Reine des Violettes' (introduced in 1860). First published in *Shrub roses of today* (1962), with *Rosa glauca* called by the now obsolete name *Rosa rubrifolia*.

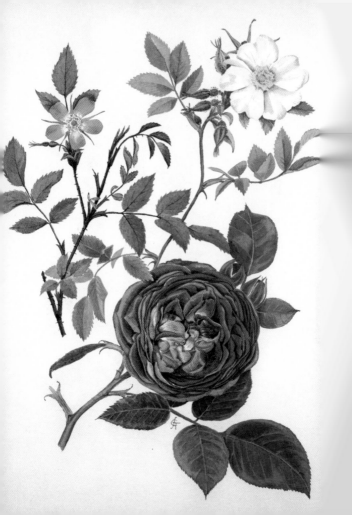

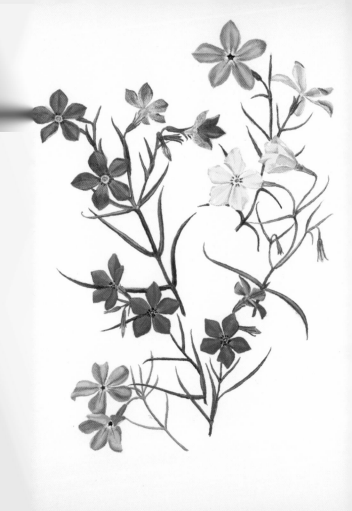

G

Forms of the American species *Phlox nana*: 'Arroyo' (first described under the obsolete specific name of *Phlox mesoleuca*) and 'Mary Maslin'. Drawn in 1986, and published in *The complete flower paintings* (1987).

G

G

G

Rhododendron 'Vanessa Pastel', a cross between *Rhododendron griersonianum* and *R.* 'Soulbut', raised at Bodnant (NT) in 1930. First published in *The complete flower paintings* (1987).

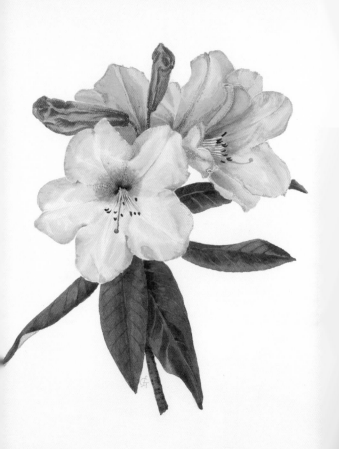

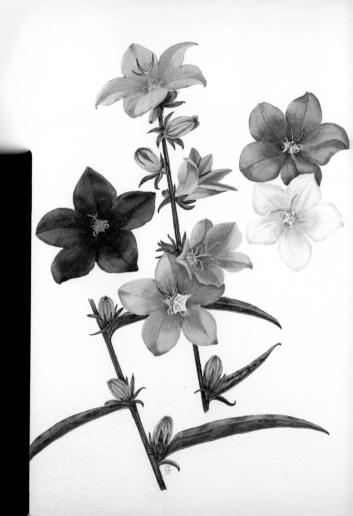

H

Campanula latiloba and some of its cultivars: *Campanula latiloba* 'Hidcote Amethyst', a sport found at Hidcote (NT) in the 1960s; *Campanula latiloba*, the species; *Campanula latiloba* 'Highcliffe Variety', and *Campanula latiloba* 'Alba'. First published in *Gardens of the National Trust* (1979).

H

H

Rosa 'Nymphenburg' was bred by the celebrated German rose grower Wilhelm Kordes, and launched in 1954. First published in *Shrub roses of today* (1962).

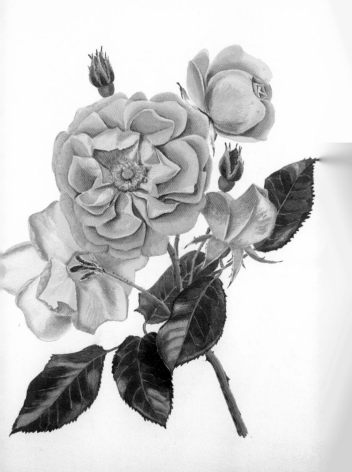

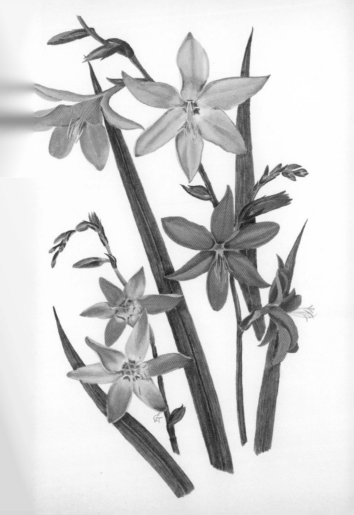

I

Three *Crocosmia* cultivars, commonly called montbretias: from the top, 'Star of the East', 'Vesuvius', and 'Queen of Spain'. The first and third received awards from the RHS before the First World War. First published in Graham Stuart Thomas' *Three gardens* (1983).

I

Lathyrus nervosus, or Lord Anson's blue pea. This was found in Patagonia on Lord Anson's expedition around the world (1704–44), and introduced by him through his brother's estate at Shugborough. When the National Trust acquired Shugborough in 1966, Graham Thomas acquired seeds of the pea to ensure it was once again planted there. First published in _Gardens of the National Trust_ (1979).

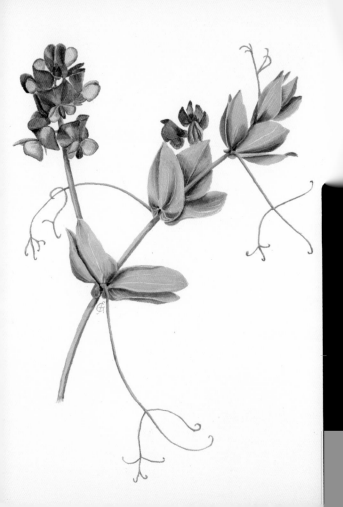

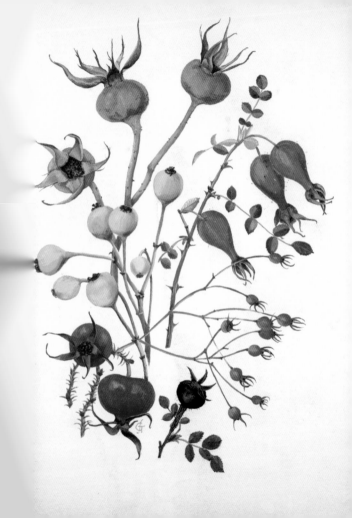

J

A drawing of rose hips. Clockwise from top: Rosa 'Nymphenburg', *Rosa moyesii*
'Geranium', 'Penelope', *Rosa filipes* 'Kiftsgate', 'Ormiston Roy', 'Fru Dagmar Hastrup',
and 'Penelope'. First published in *Shrub roses of today* (1962).

J

Hypericum 'Rowallane', a hybrid between *H. leschenaultii* and *H. hookerianum* 'Rogersii'; the original seedling was found growing at Rowallane (NT) and introduced into cultivation by the garden's owner, Hugh Armytage Moore, receiving an Award of Merit in 1943. First published in *Gardens of the National Trust* (1979).

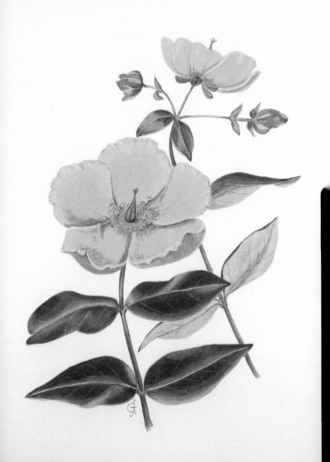

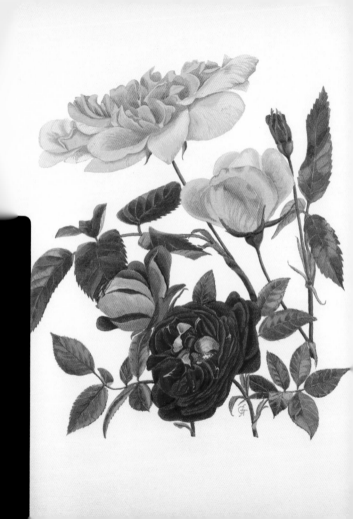

K

Rosa 'Madame de Sancy de Parabère', introduced in 1874 by the Bonnet
nursery in Nancy, and 'Amadis', a Boursault rose introduced by Laffay in 1829.
First published in *Climbing roses old and new* (1965).

K

Primula 'Devon Cream', a cultivar found at the Garden House, Buckland Monachorum, Devon, before the Second World War, and _Viola_ 'Huntercombe Purple', an old-fashioned cultivar bred by Eleanor Vere Boyle, who wrote under the name E.V.B., and whose garden at Huntercombe, Buckinghamshire, was influential in the late 19th century. First published in _The complete flower paintings_ (1987).

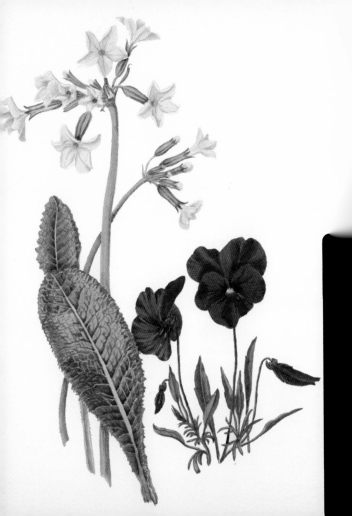

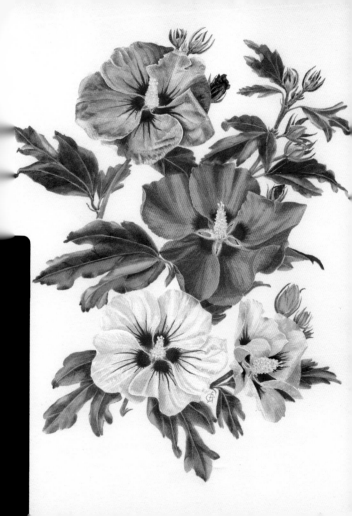

Four modern cultivars of Hibiscus syriacus: 'Blue Bird', 'Woodbridge', 'Dorothy Crane', and 'Hamabo'. First published in Graham Stuart Thomas' *Three gardens* (1983).

L

L

L

Rhododendron × laerdal, a hybrid between *R. dalhousieae* and *R. johnstoneanum* raised at Trengwainton (NT) in the 1930s, but not widely known until the 1960s. The other plant depicted is *Kennedia rubicunda,* an Australian plant also grown at Trengwainton. First published in *Gardens of the National Trust* (1979).

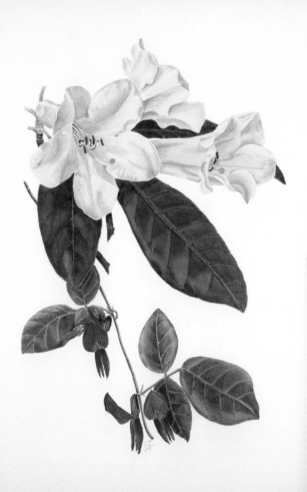

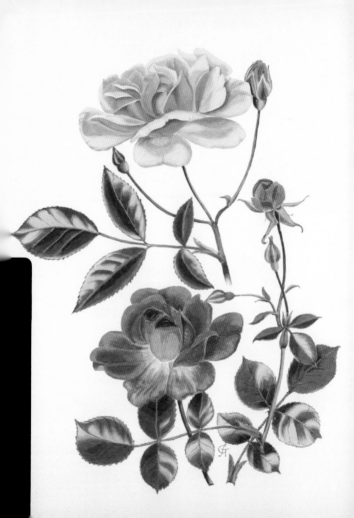

Two roses bred by the Orléans firm of Barbier & Cie: 'Auguste Gervais' (1918) and 'Alexandre Girault' (1909), both more popular today on the continent of Europe than in Britain. First published in *Climbing roses old and new* (1965).

M

M

M

Meconopsis 'Slieve Donard' (infertile blue group): a hybrid between *Meconopsis grandis* and *M. betonicifolia*, raised at Mount Stewart (NT), where it was called 'Prain's Variety', and given to the Slieve Donard nursery in the 1930s. First published in *Gardens of the National Trust* (1979).

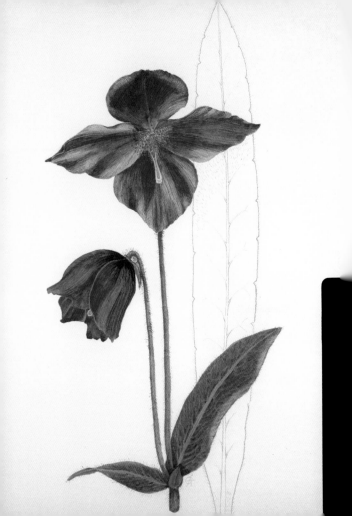

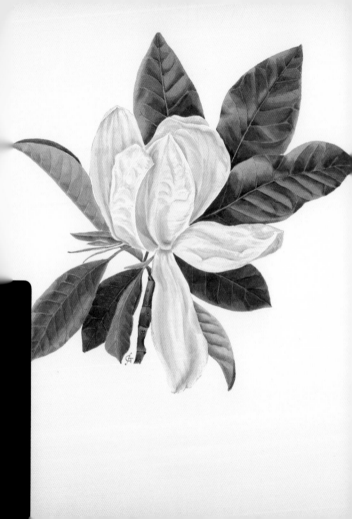

Magnolia × thompsoniana, a 19th-century hybrid between M. *tripetala* and M. *virginiana*.
Graham Thomas recommended it to Trengwainton (NT), where Edward Bolitho was already growing
all the magnolias he could. First published in Graham Stuart Thomas' *Three gardens* (1983).

N

Rosa 'Lawrence Johnston' was originally bred by Pernet-Ducher in the 1920s, and introduced to Hidcote (NT) by Johnston; in 1950, Graham Thomas introduced it through Hilling's as 'Hidcote Yellow', but renamed it in order to avoid confusion with 'Hidcote Gold'. Also _Rosa_ 'Cupid', a Hybrid Tea introduced by Cants of Colchester in 1915. First published in _Climbing roses old and new_ (1965).

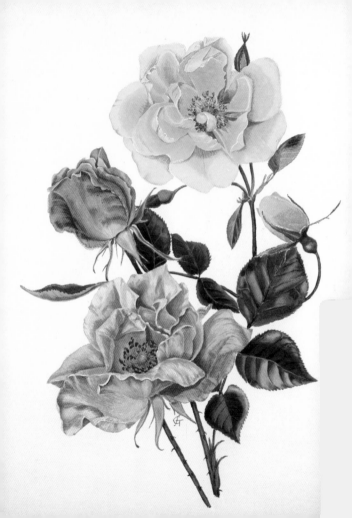

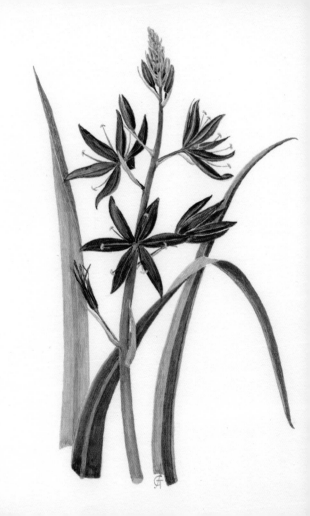

O

Camassia leichtlinii subsp. *suksdorfii* 'Lady Eve Price', a cultivar raised by Sir Henry Price at his garden, Wakehurst Place (later NT), which was given an Award of Merit in 1963. First published in *The garden throughout the year* (2002).

O

Three cultivars associated with Hidcote (NT): *Hypericum* 'Hidcote', which by mid-century had become the most popular *hypericum* variety (and which Lawrence Johnston claimed to have collected in China); *Penstemon* 'Hidcote'; and *Fuchsia* 'Hidcote'. First published in *The complete flower paintings* (1987).

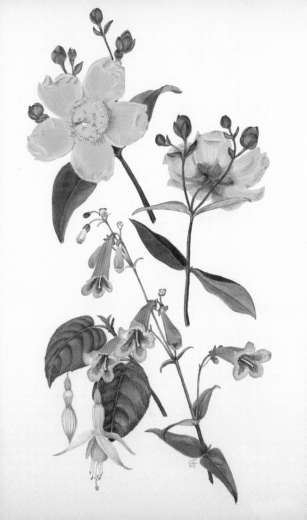

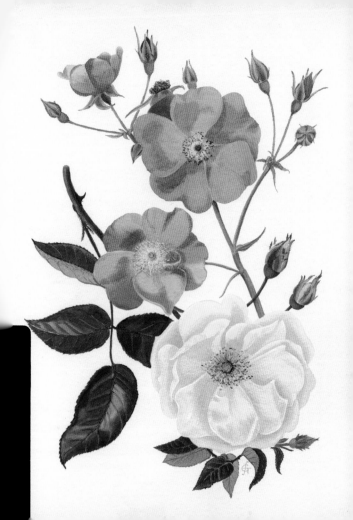

Two Hybrid Musk roses bred by the celebrated Romford rosarian Joseph Pemberton: 'Vanity' (1920), last listed in the RHS *Plant Finder* in 2007, and 'Pax' (1918). First published in *Shrub roses of today* (1962).

P & Q

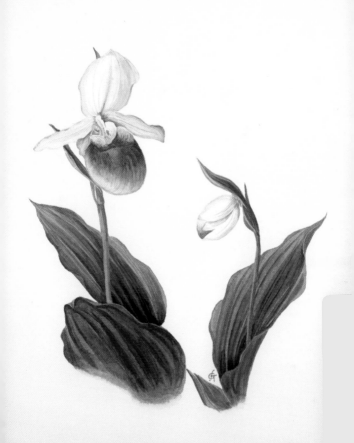

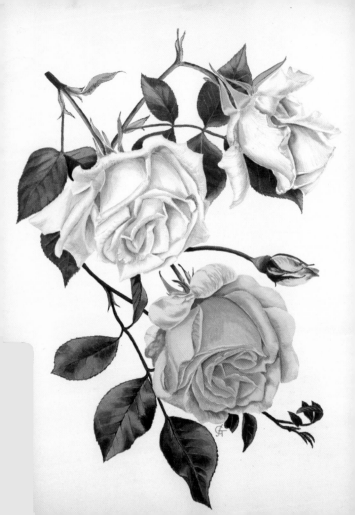

Two climbing varieties of well-known early 20th-century roses, which became more popular than their original bush forms: 'Climbing Mrs Herbert Stevens' (Pernet-Ducher, 1922), and 'Climbing Lady Hillingdon' (J.S. Hicks of Texas, 1917). First published in *Climbing roses old and new* (1965).

R

Helleborus 'Bowles's Yellow' and *Helleborus atrorubens*. Bowles gave his plant to the Cambridge Botanic Garden, and Graham Thomas was given a clump in the late 1920s. As it did not come true from seed, he could not determine its ancestry, and called it 'Bowles's Yellow'. First published in *Colour in the winter garden* (1967).

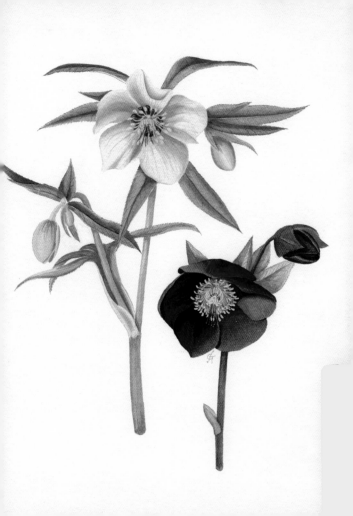

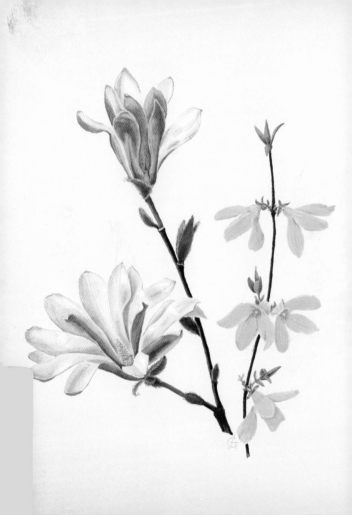

Two flowering shrubs associated with Nymans (NT): *Magnolia* × *loebneri* 'Leonard Messel', which began life as a seedling from *Magnolia stellata* 'Rosea', and *Forsythia suspensa* 'Nymans'. First published in *Gardens of the National Trust* (1979).

S

S

S

This drawing shows five stages in the development of *Rosa × odorata* 'Mutabilis', a rose of uncertain origin and date, introduced into commerce by the Swiss nurseryman Henri Correvon in 1933. Also shown is an English cultivar, 'Buff Beauty', bred by J.A. Bentall of Havering in 1939, and today the most widely grown of Hybrid Musk roses. First published in *Shrub roses of today* (1962).

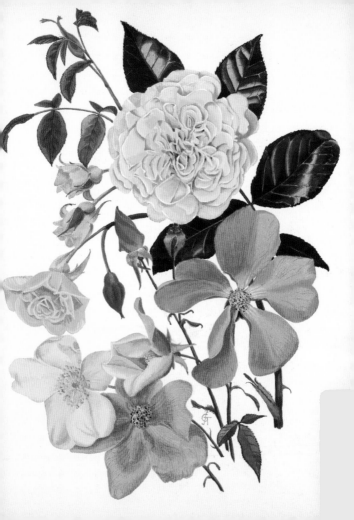

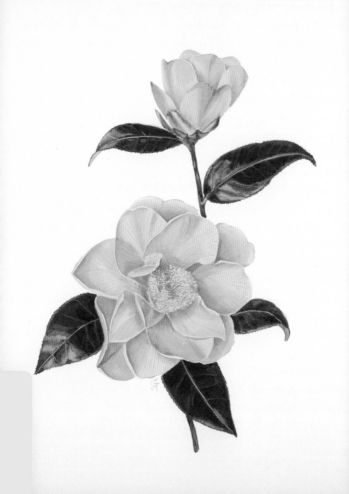

Camellia × *williamsii* 'Citation', a cultivar which originated at Bodnant (NT) before 1960. First published in *Gardens of the National Trust* (1979).

T

Camellia sasanqua 'Crimson King' and *Viburnum* × *bodnantense* 'Dawn', raised at
Bodnant (NT) from a cross between *V. farreri* (formerly known as *V. fragrans*) and
V. grandiflorum. First published in *Colour in the winter garden* (1967).

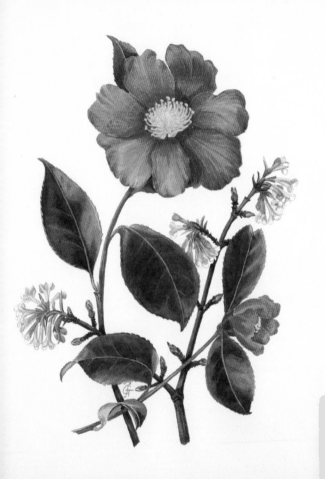

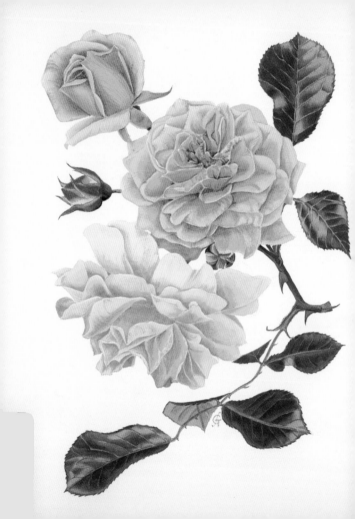

U & V

'Dream Girl', a *Rosa wichuraiana* hybrid, was bred by the New Jersey rosarian Martin Jacobus in 1944; popular as a pillar rose in the mid-20th century, it was last listed as commercially available in 2008. First published in *Climbing roses old and new* (1965).

U&V

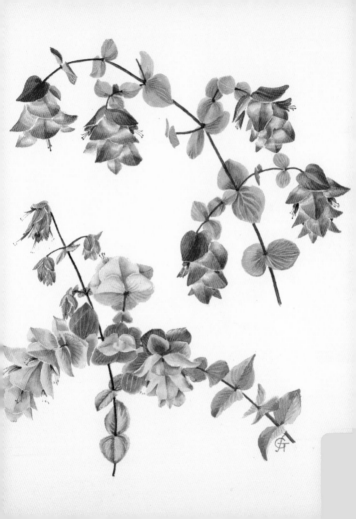

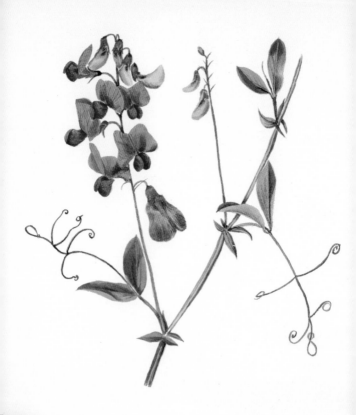

Lathyrus latifolius, the everlasting pea, a native
species of Europe. Not previously published.

W

Two traditional bulbous plants: *Chionodoxa luciliae*, which was introduced in 1877 by the tile manufacturer and plant collector George Maw at his house Benthall Hall, Shropshire (now NT). With it is *Narcissus 'Eystettensis'*, a 17th-century cultivar. The *chionodoxa* part of the drawing was reproduced in *Gardens of the National Trust* (1979).

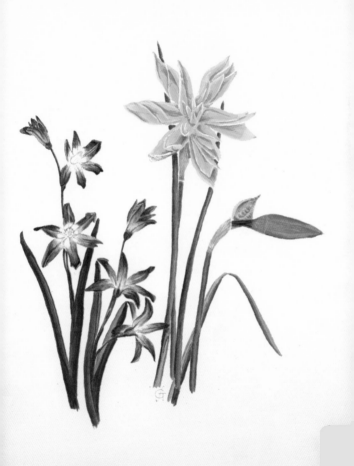

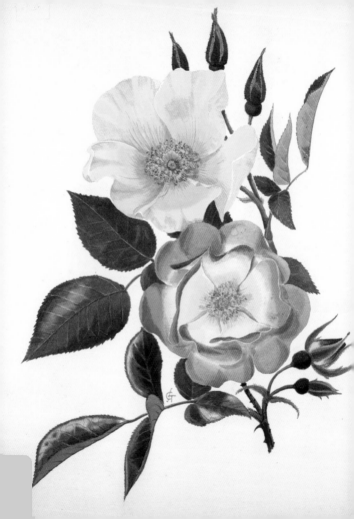

XYZ

Rosa 'Golden Wings', a cultivar raised in 1958 by the American amateur Roy Shepherd, whose *History of the rose* (1954) was the classic in the field before Graham Thomas began publishing. Also shown is *Rosa* 'Erfurt', introduced by Wilhelm Kordes in 1931. First published in *Shrub roses of today* (1962).

XYZ